KU-772-167

SILHOUETTES

Peggy Hickman

CASSELL · LONDON

A

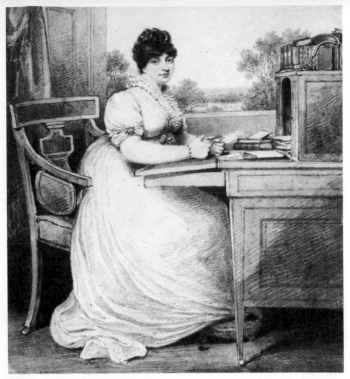

Princess Elizabeth, third daughter of George III, engaged in her favourite hobby of cutting silhouettes. She is shown seated by a window at Windsor Castle. Painted by H. Edridge. (Royal Collection at Windsor by Gracious Permission of Her Majesty Queen Elizabeth II.)

CASSELL & COMPANY LTD
35 Red Lion Square, London WC1
MELBOURNE, SYDNEY, TORONTO
JOHANNESBURG, AUCKLAND

© *Mrs P. Hickman 1968*
First published 1968

Phototypeset and printed by BAS Printers Limited, Wallop, Hampshire
F.1167

S.B.N. 304 92864 x

Contents

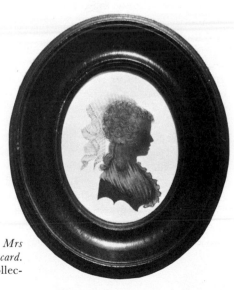

An unknown girl by Mrs Beetham. Painted on card. c. 1785. (Author's collection.)

Introduction

What are silhouettes? They are the shadow-portraits much
in vogue with our ancestors between 1770 and 1860. Their
older name was 'shades' or 'profiles in miniature' and the
best were painted, and not cut with scissors as is sometimes
supposed.

Most collections of silhouettes begin by the collector
finding an early example by one of the chief masters of the
art. Perhaps a beautiful profile by John Miers or Mrs
Beetham. Gradually he acquires others and the 'collecting
bug' really gets him. Not only does he seek the work of other
artists but, in due course, different techniques. Presently he
has silhouettes painted on plaster, glass or card, silhouettes
cut and gilded; even minute silhouettes painted on ivory
and set in jewellery. This little book offers an introduction to
the subject. It is not addressed to the established collector,
but to those who, seeing these profiles from a bygone age in
salerooms and antique shops, seek preliminary knowledge
and guidance.

Collecting silhouettes is a fascinating hobby with a dual
source of interest. Not only is there the joy of finding these
attractive profiles in their charming contemporary frames,
but often, since the art of silhouette is a relatively neglected
subject, the added pleasure of discovering fresh data about
the men who made them. Many books have been written
about porcelain, glass and bric-à-brac but less than a dozen
on silhouettes. Most of these are expensive and are now out
of print. There are a number of keen collectors in this
country and in America. In spite of this the field remains
open for the novice collector. Although profiles by the
foremost eighteenth-century profilists make their prices,
they are even now undervalued, and Victorian silhouettes
can still be found for a few pounds.

1. Origins and Methods

If you are interested in silhouettes you will want to know something about their history. Our earliest ancestors traced shadows on the walls of their cave dwellings, so that it can be claimed that in silhouettes we find the origin of all art. According to a delightful legend in Pliny, the first portrait was made by Korinthia, daughter of Debutades, a potter, who drew the shadow of her departing lover in order to preserve his likeness. Black profiles appear on Etruscan pottery, Egyptian murals and in puppets of great antiquity from the Orient, so it is evident that men have made shadow portraits all over the world since the dawn of civilization.

The word silhouette is comparatively modern and was coined in the nineteenth century from the name of Etienne de Silhouette (1709–67), a frugal French Controller-General of Finances, whose favourite hobby was the cutting of profiles from black paper. He did not invent the art but his name was applied to it derisively by those who considered all shades and profiles in miniature cheap and niggardly.

One of the earliest silhouettists in England must have been Mrs Elisabeth Pyburg who, it is said, cut profiles of William and Mary. By the mid-eighteenth century the art was well known as an amusing hobby practised by amateurs. Swift (1667–1745) made several references to silhouettes in his *Miscellanies*. For instance, in lines 'On Dan Jackson's picture cut in paper':

> Clarissa draws her scissors from the case,
> to draw the lines of poor D-n J-ns face.

The hey-day of silhouettes lasted for a brief period of about ninety years, from 1770 to 1860. During that time, until the invention of photography, they met real need. Several reasons contributed to the immense popularity of silhouettes by professional artists. The public was provided for the first time with accurate likenesses at small cost.

5

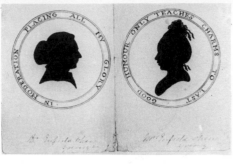

(Left) *Gentleman painted on card. Artist unknown. c. 1775.* (Author's collection.) (Right) *Amateur silhouettes from a scrapbook: Dr William Enfield, Headmaster of the Warrington Academy for Dissenters, and his wife. c. 1770.* (Mrs Rex Aitkens.)

There was no need for lengthy sittings and any number of copies could be supplied. The eighteenth century was a great age for travel. People came and went; they made new friends with whom they exchanged 'shades' as we do snapshots.

Through the history of silhouettes we follow changing modes; and there are no more delightful and attractive things than these somehow rather moving 'shades' of our ancestors. The eighteenth century was an age of great elegance. Men wore wigs and women dressed their hair in long ringlets tied with ribbons. With the turn of the century feminine hair styles became simpler and the peruke had almost vanished before Trafalgar in 1805. In the full-length silhouettes of the Victorian age one sees the growing popularity of frock coats, crinolines and shawls, and frilly pants emerge well beneath the mini-skirts in vogue for infants of both sexes.

SHADOW PORTRAITS AS A HOBBY

A French print, 'Portraits à la Mode', engraved by Jean Ouvrier, shows us a typical scene in many family circles of the eighteenth and nineteenth centuries. During that period many families enjoyed the hobby of silhouette-making at home. One finds frequent references to shadow portraiture in letters and journals of those days. Thus in 1797, Benjamin

6

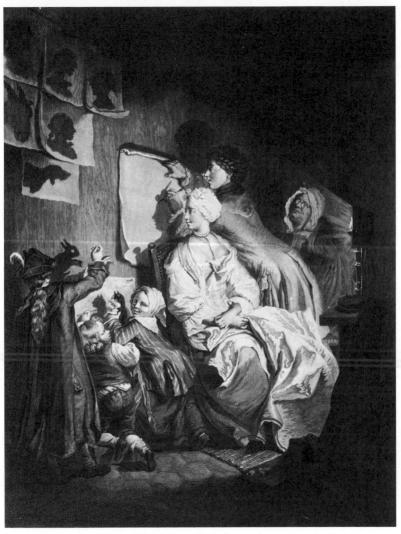

An engraving by Jean Ouvrier showing the popular hobby of silhouette-making at home. (Lavater's *Essays on Physiognomy.*)

Constant, writing to Madame de Charrière (formerly Belle van Tuyll, the 'Zelide' once courted by Boswell), said: 'I know of no profile more expressive than yours. I used to watch it on the wall while we were talking together.' He complained of a silhouette she had sent him cut out by their friend, Mademoiselle Moula: 'She has given you the outline of a stout Dutch peasant; she might have done better than that.' Princess Elizabeth, third daughter of George III, was an enthusiastic amateur profilist. An album of her cuttings, including portraits of her parents and allegorical subjects, is now in the Royal Collection at Windsor. In 1802 Henry Edridge painted the Princess seated in a window, scissors in hand, engaged in her favourite hobby of cutting silhouettes from paper.

It is well known that the advent of photography brought a decline in the demand for silhouettes by professionals. Perhaps it is not generally realized that the introduction of gas and electricity were equally responsible for the disappearance of silhouette-making as a hobby. Modern overhead lighting banished the deep shadows which amateur profilists had found so invitingly thrown on walls by lamp and candle-light.

The art of profile-making was considered a desirable accomplishment. It was even taught as a genteel pursuit in some fashionable schools. The well-known profilists, Torond and Wellings, both advertised as drawing masters on their trade labels, and Thomason of Dublin offered to give lessons by post: 'Clients not coming to Town may by directing a line as above, have instructions as will enable those who cannot draw to take each other's shades from life, which may be sent to be correctly finished in Town, and they can rely on having justice done to them and every mistake rectified, as if they were present on the spot.'

JOHANN CASPER LAVATER (1741–1801)
Between 1775 and 1778, a Swiss clergyman, Johann Casper Lavater, published a book of great importance, a best-seller for many years, destined to raise the art of silhouette from a

Lieutenant-Colonel George Baker, by John Miers. Painted on plaster and bronzed. c. 1810. (Author's collection.)

Mrs Sophia Baker, by John Miers. Painted on plaster. c. 1790. (Author's collection.)

Églomisé silhouette of an unknown lady. Austrian. c. 1790. Signed 'HAUK FECIT GOTHA'. (Author's collection.)

Églomisé silhouette of an unknown man. German. c. 1790. (Author's collection.)

Sailing boats. Scene cut from paper by unknown artist. (Ex Nevill Jackson collection; now author's collection.)

An officer of the 89th Regiment by J. Buncombe painted on card. (Mr Jack Pollak.)

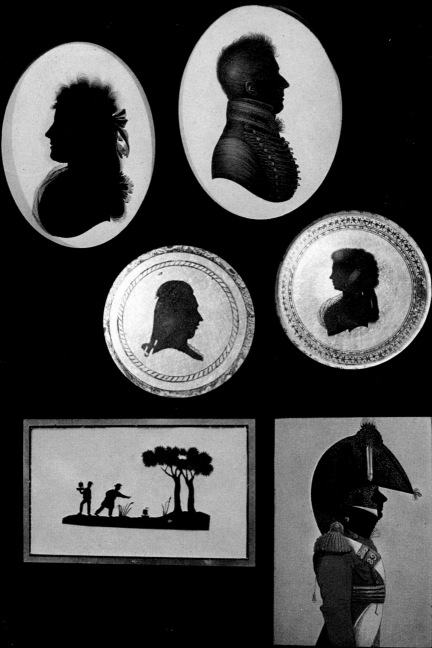

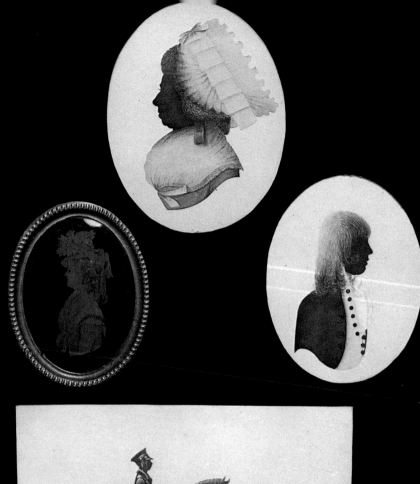

A lady 'Mrs Twigge, taken August 1786'. Painted on plaster by W. Phelps. (Mr Jack Pollak.)

A boy 'taken 1791' by W. Phelps. Painted on plaster. (Mr Jack Pollak.)

A lady by W. Spornberg. On the reverse side of glass. Signed 'W. Spornberg fecit. Bath 1793'. (Mr Jack Pollak.)

Children with a pony. Cut and bronzed and stuck on hand-painted background. Signed 'Frith 1844'. By F. Frith of Dover. (Mr Jack Pollak.)

light-hearted pastime to a serious form of portraiture. In his *Essays on Physiognomy calculated to extend the Knowledge and Love of Mankind*, Lavater claimed that plain black profiles were the most penetrating guide to character reading. His book was illustrated by numerous silhouettes. Hundreds of people rushed to have their profiles drawn, and sent him subscriptions towards publication, hoping no doubt that they would be included in his work with a flattering delineation of their personalities. In these days of flimsy paperbacks, it is worth noting that our ancestors were not deterred by literally weighty reading. My leather-bound edition of Lavater weighs thirty-four pounds. Soon after publication Betsy Sheridan, sister of Richard Brinsley Sheridan, the playwright and politician, wrote to her sister: 'I have been reading Lavater and intend becoming wise in my judgements on the cut of people's faces, for he does not advance the general idea of particular passions and dispositions impressing certain lines on the countenance but positively insists that a nose or mouth of a certain formation, almost invariably belongs to a particular character.' After the impact of this book on the already profile-conscious age, those who had been content with home-made shadow portraits felt the importance of accuracy. Small wonder when a slip of brush or scissors might mean too full a lip or sloping forehead, which, according to Lavater, denoted sensuality or near idiocy.

The public needed accurate profiles made by professional artists. Lavater, assisted by the poet Goethe, himself an amateur profilist, invented a special silhouette chair designed to keep the head in a rigid position. The subject's shadow was thrown on a transparent paper screen and the artist drew round this profile from the other side. Life-size shadows were reduced to the required size by means of a pantograph, an instrument still used in draughtsmen's offices.

A hollow-cut silhouette thought to be of Jane Austen, by Mrs Collins. c. 1801. (National Portrait Gallery.)

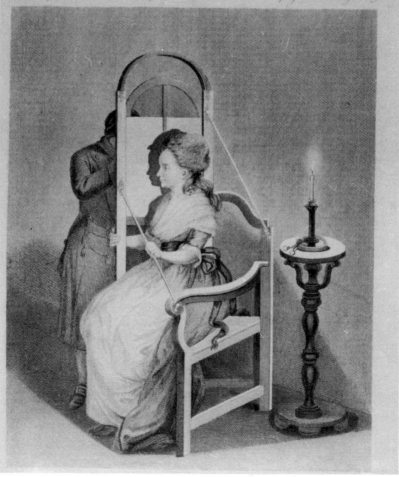

A SURE AND CONVENIENT MACHINE FOR DRAWING SILHOUETTES.

This is the Character I would assign to the silhouette of this Young person. I find in it Goodness without much Ingenuity; Clearness of Idea, & a ready Conception; a mind very industrious but little governed by a lively Imagination & not attached to a rigid punctuality. We do not discern in the Copy, the Character of Gaiety which is conspicuous in the Original, but the Nose is improved in the silhouette, it expresses more Ingenuity.

Lavater's special silhouette chair, from an illustration in his Essays on Physiognomy.

PROFESSIONALS TAKE OVER

In response to public demand, professional artists willing to cash in on the latest craze opened studios in most of the larger towns. Bath, then a fashionable spa for the leisured classes, became a popular centre for profilists. Some artists made tours of the country, advertising their impending arrival in the local press.

In England, one of the earliest professional profilists was Mrs Sarah Harrington, of Bath and London, who patented a machine for hollow cutting silhouettes. (In this method the profile was traced on white paper, then the face was cut out and the hollow profile placed over a sheet of black paper.) Mrs Harrington worked at Bath from 1770 to 1788 and was succeeded there by her one-time assistant, Mrs Collins. Wedgwood used a profile cut by Mrs Harrington to obtain a likeness for his medallion of Maria Edgeworth, the authoress. The National Portrait Gallery has an interesting hollow-cut silhouette, thought to be of Jane Austen and possibly by Mrs Collins. This profile was found pasted into a second edition of *Mansfield Park*. Above the head is written in faded handwriting: 'L'aimable Jane'. Comparison with the only other known portrait, an unfinished sketch by her sister Cassandra, leaves little doubt that this is indeed a shade of the immortal Jane.

TRADE LABELS

Everyone likes to know, if at all possible, where their finds were made and by whom. This is where trade labels can help the collector.

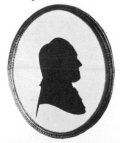

The majority of profilists used printed labels pasted to the backs of their frames. These gave details of the methods employed, the time needed for a sitting, their prices and the addresses

Hollow-cut silhouettes of Mr and Mrs James Leigh Perrot (Jane Austen's uncle and aunt), by Mrs Harrington of Bath. c. 1775. (Jane Austen Memorial Trust.)

of their studios. Often these labels have been removed by former owners; sometimes traces of them can be found under more modern layers of brown paper. The presence of a label adds value to a silhouette as a proof of identification of the artist responsible. Some men signed their work, but they were in the minority; for instance, Edward Foster signed sometimes, but not always, beneath the bust line of his profiles. Some others signed occasionally, but used labels in addition, notably A. Charles and August Edouart. John Miers never signed except on his very minute profiles painted on ivory and set in jewellery.

In spite of the interest and value of labels, the collector's first thought should not be 'Who is it by?', but rather, 'Is it an attractive silhouette of the highest quality?' Identification of different artists' techniques will often become possible as the collector becomes more familiar with his subject. Many museums have silhouettes on view. Desmond Coke, author of *The Art of the Silhouette*, left his collection to the Victoria & Albert Museum. These silhouettes are kept in the Print Room, where they may be seen on request.

In the library of the Victoria & Albert, collectors will find the invaluable books written by the late Mrs E. Nevill Jackson, a pioneer writer on silhouettes. Her last book, *Silhouette*, published in 1938 and now out of print, remains the most comprehensive authority on the subject.

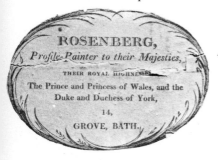

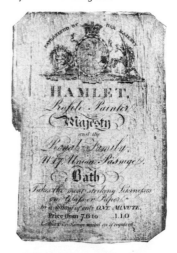

(Above) *Trade label of Charles Rosenberg*. (Author's collection.) (Right) *Trade label of William Hamlet of Bath*. (Author's collection.)

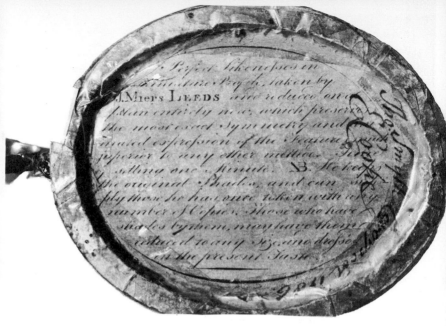

John Miers's first Leeds label. (Author's collection.)

Mrs Beetham's trade label. (Author's collection.)

Trade label of A. Charles of The Strand. (British Museum.)

TECHNIQUES

Now we come to how silhouettes were made. They vary tremendously in quality, from finely painted miniatures in monochrome to rapid impressions cut from paper. There were several different ways of making them. For purposes of simplicity, those most likely to concern the general collector can be classified under four different types:

1. Shoulder-length profiles, painted in indian ink or pine-soot, on ovals of specially prepared chalk-like plaster.

2. Silhouettes painted on the reverse side of convex or flat glass.

3. Silhouettes painted on card.

4. Silhouettes cut from black paper, either free-hand or with scissors.

These four methods each had their own variations. These will be discussed as each type is considered in succeeding pages of this book.

Some collectors may wish to increase the scope of their collections. Those with deep pockets might include silhouette jewellery and profiles painted in black on porcelain; those with more modest means, but with a zest for the hunt, would find it profitable to collect silhouette prints, still to be found sometimes at antiquarian booksellers.

Profiles were painted in black on porcelain in England and on the Continent. They were generally gift or memorial pieces. A silhouette of George III was made for his Jubilee

F. Torond's trade label. (British Museum.)

by the Worcester factory in 1809. It was accompanied by various captions: 'Long may he reign', 'An honest man is the noblest man of God', etc.

Minute silhouettes were painted on ivory or glass and set, in gold or pinchbeck, as rings, brooches or lockets.

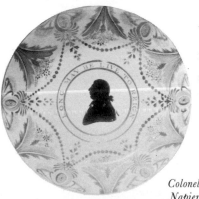

Profile of George III painted on a Worcester plate in 1809, the year of his Jubilee. (Royal Collection at Windsor, by Gracious Permission of Her Majesty Queen Elizabeth II.)

Colonel the Hon. George and Lady Sarah Napier (formerly Lady Sarah Lennox), painted in 1794 on plaster, by John Miers. 2½ in. × 3¼ in. (Author's collection.)

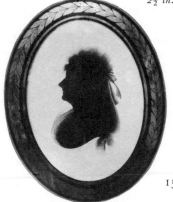

15

2. Silhouettes 1770–1820

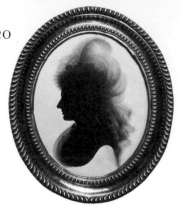

The scope of this book will only allow mention of those artists who made the most attractive and collectable silhouettes. It would merely confuse the reader to describe in detail the work of the sixty or more men and women who comprise the British school of profilists. Suffice to say that the best silhouettes were made between 1770 and 1820. During that time there were at least twenty-five artists of outstanding ability. There will be reference to many of these in the following pages.

JOHN MIERS AND HIS SCHOOL

It now seems time to say something about John Miers (1756–1821), who is considered by most collectors to be the greatest profilist of all. His work stands in a class of its own. Although he sometimes painted on card, his finest silhouettes are on ovals of white plaster. The profiles of his subjects are in dense black, but hair, veils and muslins are softly touched in black thinned to a smoky, diaphanous grey.

Miers was born in Leeds. His father, a coach painter by trade, owned a business for supplying artists' materials. Young Miers married in 1781 and opened his own shop at The Golden Tarr, Lowerhead Road, Leeds. From this address he advertised his willingness to take 'Profile Shades in Miniature; most striking likenesses drawn and neatly framed at 2/6 each. A second draught from the same shade 2s.'

Some of his most beautiful work dates from this early period. Soon his home town provided too little scope for his talents, and between 1783 and 1786 he made a tour of Newcastle, Manchester, Liverpool and Edinburgh. In

Manchester he made a silhouette of the great actress Sarah Siddons and, with her permission, offered copies of this lovely profile to the public. In Edinburgh he took several shades of Burns, one of which is now in the National Portrait Gallery of Scotland. Did the poet have this painted for 'Clarinda' (Mrs MacLehose), with whom he had exchanged so many tender letters? She gave him her profile by Miers, painted on ivory and set in a breast pin. 'I shall go to Miers alone,' she wrote. "Tis quite the usual thing I hear . . . What size do you want it about?'

In 1788 Miers came to London and set up business at No. 62 The Strand as a profile painter and jeweller. He remained there for three years and then moved his studio to No. 111 in the same street. By now he had established a great reputation. His trade label of this period reads as follows:

MIERS
PROFILE PAINTER AND JEWELLER
(111, Strand, London)
Opposite Exeter Change
Executes Likenesses in profile in a style of superior excellence with unequalled accuracy, which conveys the most forcible expression and animated Character even in the very minute size for Rings, Brooches, Lockets, etc. etc.
Time of sitting 3 minutes.
Mr Miers preserves all the original sketches from which he can at any time supply Copies without the trouble of sitting again.
N.B. Miniature frames and convex glasses wholesale and retail.

On some of his earlier labels he had mentioned: 'Likenesses preserved AND DRESSED TO THE PRESENT TASTE.' A few years ago I came upon interesting proof that some clients took advantage of this offer. In 1798 Elizabeth Fry, the great prison reformer, came to London and sat for her profile by Miers. She was seventeen at the time. Her diary describes how, before a party, her hair was dressed in a fashionable

17

mop of Grecian curls and tied with a ribbon, 'and I looked like a monkey', she wrote. The following year she became a strict Quaker and always after that date wore a plain cap. Miers's silhouette taken in 1798 shows her with curls and a ribbon, but I have seen another version of the same profile in which she wears a Quaker cap. Evidently she had asked for a repeat copy, or copies, of the original shade with a cap to replace curls.

Miers has left us shadow portraits of many of the great personalities of his age. Collectors will sometimes experience the joy of finding a profile of some interesting man or woman, of whom no other likeness exists. For instance, the National Portrait Gallery now have the photograph of a silhouette in my collection, by Miers, of Cassandra Austen, the beloved sister of Jane.

Miers excelled in his profiles of beautiful women and in the sensitive faces of young children, but he was no flatterer and it is evident that he had not only the gift of obtaining a good likeness, but also an almost uncanny insight into character. His profile of George III must have been an exact likeness. I believe that this silhouette gives us a more accurate idea of how the King appeared to his contemporaries than any other portrait of him ever made. This is as Fanny Burney must have seen him when she recorded daily happenings at Court. Even if the identity of this profile was not known, we should say that here was a man of low mental calibre, slow, stupid and ponderous.

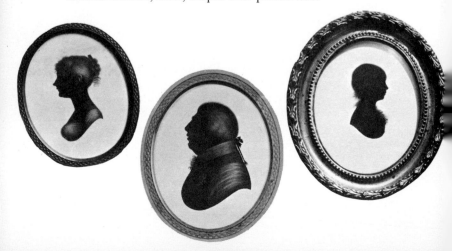

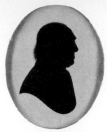

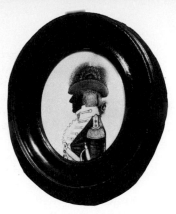

(Right) *Silhouette of an officer, painted on plaster. A rare example of W. Phelps's work in black and white. 2½ in. × 3¼ in.* (Author's collection.)

(Above) *Jeremy Bentham, social philosopher. Painted in brown and gold on plaster, by John Field.* (National Portrait Gallery.)

After establishing himself at 111 The Strand, Miers branched out in several directions: pearwood or papier-mâché frames replaced the earlier ovals of hammered brass used during his Leeds period. His profiles were now set under convex glasses with handsome black and gold borders. He trained several apprentices to help in his expanding business; notably Samuel Houghton, Thomas Lovell and John Field. Both Houghton and Lovell eventually set up on their own, the former in partnership with G. Bruce of Edinburgh, and the latter in Cheapside, London. Their style very much resembles that of their former master.

Acceptable work was also done by T. Smith of Edinburgh and Mrs Lightfoot of Liverpool. Both these artists painted on plaster in a technique similar to Miers's. Profiles by the latter were dense black with draperies outlined with thin black lines, less beautiful than the soft, cloudy effect achieved by Miers.

Although his working years slightly overlap the period now under consideration, this seems a convenient moment to say something about John Field (1771–1841), Miers's

(Far left) *Cassandra Austen, sister of Jane Austen. Painted on plaster and bronzed by John Miers. c. 1812. 2¼ in. × 3½ in.* (Author's collection.) (Centre) *George III, painted on plaster and bronzed, by John Miers. c. 1809.* (Formerly H. Blairman & Sons Ltd.) (Right) *Master Duncan, painted on plaster by G. Bruce of Edinburgh. c. 1795. 2½ in. × 3¼ in.* (Author's collection.)

chief assistant for thirty years. He was a skilled water-colourist and exhibited at the Academy charming little landscapes painted in monochrome on ovals of plaster. Soon after 1800 details of Miers's silhouettes were often touched with gold or bronze paint. Field is thought to have introduced this method of embellishment. Strictly speaking, a shadow portrait can have no contours, and bronzing deflects from the simple beauty of plain black silhouettes; even so, one has to admire Field's good brushwork, and his profiles, sometimes painted in dark brown and heavily bronzed, are well executed though they lack the magical softness of touch possessed by his master. It is probable that in the latter years of Miers's life many profiles bearing his labels were in fact made by Field or the firm's other assistants.

After John Miers's death in 1821, Field and the profilist's son, William Miers, carried on the business in partnership. In 1830 this partnership was dissolved and Field, who was appointed 'Profilist to Queen Adelaide', moved to No. 11 The Strand. He remained in business there until his death in 1841. John Miers had had an exceptionally long professional career, during which he had made literally thousands of silhouettes, consequently the collector still stands a good chance of finding some of his fine work. His profiles are not rare, although this does not mean that they are to be found round every corner. Many doubtless have been damaged and discarded, while others are in museums or in private collections, but even today, many more must remain unrecognized in private homes.

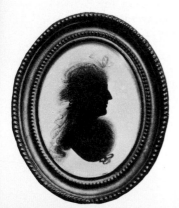

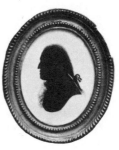

Lady Rogerson Mathew, by I. Thomason. Painted on plaster. c. 1792. $2\frac{1}{2}$ *in.* × $3\frac{1}{4}$ *in.* (Author's collection.)
George Washington, painted on plaster by I. Thomason. (Sulgrave Manor Trust.)

Another artist who ranks very high among eighteenth-century profilists is I. Thomason. His fine silhouettes on plaster are in oval hammered-brass frames similar to those used in Miers's early work. In the absence of a trade label, there are two clues which help to identify silhouettes by Thomason. He frequently painted a bow of ribbon beneath the bust of his female sitters, and a close inspection of hair and muslins will show that these, in places only, are outlined with thin black lines.

After working for some years in London, Liverpool and Newcastle, Thomason went to Dublin in 1790. He opened a studio first at 25 Great South George Street, then at 33 Capel Street. His trade label claimed that he 'preserves ye most exact symmetry and animated expression of ye features'. After two years he advertised that his departure from Dublin was 'positively determined upon', and after thanking his patrons for their support, he asked those who had left their 'shades' with him to send for them. A very fine likeness of George Washington, painted by Thomason on plaster, is now one of the treasures at Sulgrave Manor, Northamptonshire.

Early in the nineteenth century Thomason changed his style and painted profiles on glass backed with wax, not a very satisfactory material since with age these have often become discoloured, cracked or brittle.

W. PHELPS OF DRURY LANE

No greater contrast can possibly be imagined between the work of previously mentioned painters on plaster and that of W.Phelps of Drury Lane, a profilist who first appeared upon the scene in the 1780s. He painted both on plaster and card and was one of the earliest men to make a discreet use of colour. For many of his female likenesses, he used touches of apple green, blue or mauve. Even in the absence of labels, his profiles have an individuality of their own. Those on card may easily be recognized by the coarse brown paper on which they were drawn. From Phelps's label one learns that, like Miers, he suggested, 'Those who have shades in

The Earl of Fingall, by Edward McGau-ran. Painted on plaster. (Author's collection.)
An unknown lady, painted on glass by Joliffe and backed with silk. (Mr Jack Pollak.)

their possession may have them copied, the Likenesses pre-served and dressed in the present Taste.' This extra service must have been a boon to country cousins: how splendidly economical to be saved visits to hairdressers and *modistes* before sitting for one's shade. I have seen examples of Phelps's work in some private collections, but it is rare.

Sometimes the collector will come across silhouettes by hitherto unrecorded artists. I have in my collection a fine profile on plaster of the Earl of Fingall by Edward McGauran of 16 Aungier Street, Dublin. This artist's name was not mentioned among the profilists listed by Mrs E. Nevill Jackson in *Silhouette*. His trade label tells us that he 'will paint busts, half-lengths, and full lengths in an improved stile of shading and likenesses engaged'; he was also ready to call at ladies' apartments to teach them 'for one guinea, the art of varnishing pier tables, screens, etc.' In the Dublin directory of 1790–92, McGauran was listed as a hairdresser, but from 1793 to 1796 as a profile painter. Mr John Woodiwiss thought highly of this unique example of McGauran's work. In *British Silhouettes* he said, 'his drawing is exceedingly strong and the detailed embellishments in mellow shades of grey and black are finely executed.' An example of McGauran's work is a worth-while acquisition

The Strand, where both John Miers and A. Charles had their studios. An early nineteenth-century drawing by A. Scarf the elder. (British Museum.)

to any collection. I would be interested to hear of other silhouettes by this forgotten artist.

PAINTERS ON GLASS AND CARD
Several men claimed on their labels that they were the original inventors of profiles on glass. It seems probable that the first man to use this method was Joliffe, the son of a bookseller in St James's Street. His silhouettes are rare and very individual in style. They were painted between 1775 and 1780 on the back of flat glass and are usually three-quarter length, posed beneath draped curtains, and backed with silk. Joliffe had been known as a cutter of silhouettes from paper for some years before this. In fact, he must have been one of the first professionals. In 1758 a friend of the poet Thomas Gray sent him a poem entitled 'Ode to Mr Joliffe who cuts out Likenesses from the Shadow at White's' (the London club). Gray requested further enlightenment about Joliffe and was told: 'Lord, you are not one of us; you know nothing of life. . . . Joliffe takes profiles with a candle better than anybody.'

By 1780 several other profilists began painting fine silhouettes on convex or flat glass. It should be remembered that most men employed more than one technique. For instance, another man working in a fashionable district of London, A. Charles of The Strand, painted on both glass and card.

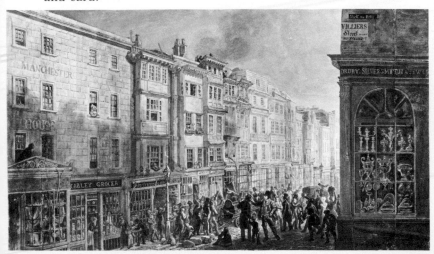

In the eighteenth century The Strand was a narrow and congested cobbled street. Among the slow-moving traffic, coaches, drays and sedan-chairs mingled with pedestrians; fashionable shops with their glistening bow-fronted windows were huddled against the lowly premises of cobblers and other artisans. Near at hand could be found amusements to suit every taste: taverns, eating houses, bagnios and theatres. Fashionable portrait painters had their studios in the neighbourhood and in The Strand itself several profilists practised the art of shadow portraiture. A few doors away from John Miers was his contemporary, A. Charles, of 130 The Strand, opposite the Lyceum, a profilist and miniaturist. Collectors usually place Charles among the first profilists of the day. Examples of his beautiful silhouettes may be seen in the Victoria & Albert Museum and in the Royal Collection at Windsor.

Fanny Burney wrote in her journal: 'Mr Charles of the Strand, to the astonishment and satisfaction of several thousands of people, has and continues to draw the Line of the human face in three minutes, and that to resemble Nature in a curious, correct and unimaginable manner, finishing in one hour by the watch.' Miss Burney's comments on Charles have been quoted by other writers on silhouettes, but I think they have missed their true significance. Why did he cause such astonishment to the public? Certainly not because he obtained a good likeness in three minutes. Most profilists took no longer than this and his neighbour, Miers, also promised 'unequalled accuracy'. Nor was it that Charles worked free-hand without the aid of instruments (though that he occasionally used these may be seen from his trade label where he mentions the use of a pantograph). Possibly the reason for such general astonishment was that passers-by could actually see Charles at work, and that he sketched his clients in a bow window, such as can be seen in Scarf's drawing, an adroit trick of showmanship which aroused interest and encouraged further custom.

24

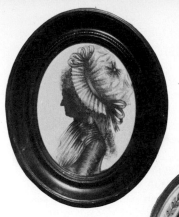

A lady, painted on card by A. Charles. 2½ in. × 3½ in. (Ex Desmond Coke collection; ex Nevill Jackson collection; now author's collection.)

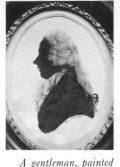

A gentleman, painted on card by A. Charles. (Victoria & Albert Museum.)

Queen Charlotte, painted on convex glass by A. Charles. (Royal Collection at Windsor, by Gracious Permission of Her Majesty Queen Elizabeth II.)

Curiously enough, this making of silhouettes in public is the only survival today of the now almost defunct art of silhouette. I have seen artists cutting profiles from paper at fair-grounds, both in this country and in Denmark.

Charles seems to have flourished in the last twenty years of the eighteenth century. His trade label reveals that he was a drawing master, and that he painted silhouettes on glass besides sketching on card. This label is headed by the delightful silhouette of a lady in court dress, and he claims that his work 'had long met with the approbation of the first people'. He also boasted, quite inaccurately, that he was the original inventor on glass. Silhouettes by Charles on glass are very rare, but I have seen many examples of his work on card. He often, but not always, signed these in small letters beneath the bust line: 'Charles', or 'Charles R.A.'. The letters R.A. are misleading. He was not a member of the

Royal Academy, though he possibly wished to be thought so.

Charles evidently prospered, for in 1793 he was appointed Likeness Painter to the Prince of Wales (later George IV). On the strength of this success, he raised his charges from three to twenty-five guineas for miniatures, and from ten shillings and sixpence to thirteen shillings for shades.

At first glance his work on card very much resembles that of Mrs Beetham; a careful comparison will show, however, that, whereas Charles painted hair in a swift tangle, his female contemporary conscientiously painted each hair of every separate lock. It is also worth remembering that Mrs Beetham finished her profiles with a distinctive line, to indicate the sitter's arm. This useful clue, learnt recently, enabled me to identify as a Beetham a fine silhouette (reproduced on page 3) painted on card which I had previously attributed to Charles.

I have never seen an ugly profile by Charles, so it would seem that he flattered his clients. From their styles of hairdressing, it is evident that he retired from business before 1800.

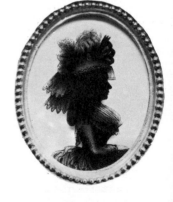

A gentleman, by Mrs Beetham. Painted on glass. Late eighteenth century. (Victoria & Albert Museum.)
A lady, by Mrs Beetham. Painted on convex glass. Late eighteenth century. 3 in. × 3¾ in. (Author's collection.)

A lady, by Mrs Beetham. Painted on convex glass. (Victoria & Albert Museum.)

According to Boswell, Dr Johnson strongly disapproved of women portrait painters. 'Publick practice of any art,' he observed, 'and staring in men's faces, is very indelicate in a female.' It is tempting to imagine his view on women profilists. True there was no peering at men's features, at least not in close proximity, since artist and subject were separated by a paper screen, but sittings were by candle-light, which one feels would hardly have conformed to the great man's ideas of decorous female behaviour.

In 1784, the year of Johnson's death, Mrs Isabella Beetham, one of the finest of all profilists, opened her studio at No. 27 Fleet Street. She had previously practised in a modest way as a profilist at Clerkenwell.

Isabella Beetham was born in 1744 at Sedgewick, Lanca-shire. Her father, whose name was Robinson, came of a staunch Catholic family, impoverished by their adherence to Papacy. At the age of twenty, Isabella made a run-away match with Edward Beetham, a well-born and versatile young man, who was employed at Sadler's Wells theatre. The young couple were very poor. This led Mrs Beetham to seek means of adding to their income. She had artistic talent and so decided to become a profilist. Her early silhouettes were cut from paper, but after taking lessons from the miniaturist, John Smart, she abandoned scissors for the brush and painted profiles on glass and card. She is con-sidered by some to be a finer artist than John Miers. Her silhouettes certainly fetch high prices, but this is partly because she was a less prolific artist. She perfected the art of painting on the underside of convex glass. Profiles were sketched in black, but all details of hair and dress were filled in with magnificently fine brushwork, giving an impression of lace-like transparency. They were set above a white plaster background in such a way as to throw a double shadow (the shade of a shade). She used convex glasses with bordered patterns in white and gleaming gold; these were framed in oval pearwood frames. The total effect of her silhouettes of eighteenth-century beaux and belles in their

27

finery is extremely beautiful, though it is doubtful if she shared Miers's gift for capturing exact likeness and character.

Unlike most of her contemporaries she made no claims to exact likenesses on her labels. On one of the earliest of these she addressed herself to: 'PARENTS, LOVERS, AND FRIENDS', and stated that the former 'assisted by her Art may see their offspring in any part of the terraqueous Globe; nor can death obliterate their features from their fond remembrance', etc.

Her subsequent labels were less sentimentally phrased and the one usually found is remarkable for its brevity:

PROFILES
IN MINIATURE BY MRS BEETHAM
No. 27, FLEET ST.

Her husband paid a special visit to Murano, near Venice, to learn the art of preparing the beautiful, decorative borders of convex glasses.

His invention of 'Beetham's Patent Washing Machine', a great novelty and the first of its kind, brought prosperity to the family. The washing machine was sold from a sale-room on the ground floor at 27 Fleet Street, his wife's studio being on an upper storey.

After her husband's death in 1809, Mrs Beetham sold the washing machine business and gave up her career as a profilist.

MRS JANE READ

The Beethams' eldest daughter, Jane, inherited her mother's artistic gifts. She was trained by the portrait painter Opie, and subsequently painted very fine profiles on the back of convex glass. She described these as 'Aqua-tinta Profile likenesses'. They were transparent, drawn on dark brown with beautifully painted surroundings of foliage and clouds, and backed with pinkish wax. The collector who has once seen her work will always be able to recognize it again.

Jane married a rich member of the legal profession. Her daughter, Cornelia Read, left considerable property to Brompton Hospital, and portraits of the Beetham family are still kept there.

CHARLES ROSENBERG (1745–1844)

We now move on to a contemporary of Mrs Beetham's, Charles Rosenberg, who owes much of his success to Royal patronage. The art of silhouette knew no more enthusiastic supporter than George III. Judging by the number of profiles of him and his spouse extant, they must have spent hours posed behind profilists' screens.

When Princess Charlotte of Mecklenburg-Strelitz came to England as the bride of George III, she brought Rosenberg, then aged fourteen, as a page in her entourage.

His aptitude for painting silhouette likenesses was encouraged by the Royal family. In time he left Court and set up as a professional profilist, first in Ramsgate and then in Cheltenham. In 1787 he moved to Bath. His earliest premises in the famous spa were at 'Mr Tucker's pencil factory', in St James's Street. After his marriage in 1790 to Elizabeth Woolley, he moved to the North Parade, where he stayed for three years before establishing himself, in 1816, at 14 The Grove.

Rosenberg was a poor draughtsman and his full-length figures are almost caricatures; nevertheless, they possess their own quaint attraction and this artist's work has always been sought by collectors. He was better at bust-length profiles and made a number of charming and dignified silhouettes of the Royal Princesses. Many of his profiles were drawn in plain black on the reverse side of flat glass and backed with pink paper. This has faded with the years and can only be seen behind the profile, if one removes the glass from its frame. At times he used a more satisfactory technique by employing a red enamel background. In his full-length

The Earl of Upper Ossory, by Charles Rosenberg. Painted on glass. 6½ in. × 7¾ in. (Author's collection.)

studies. Rosenberg introduced white or coloured enamel. He made some delightful conversation pieces of George III with his family or ministers; being evidently incapable of composition, their figures are grouped in a simple 'all-in-a-row' manner.

I have in my collection an amusing silhouette by Rosenberg of John Fitzpatrick, second Earl of Upper Ossory, the Irish peer who in 1769 was involved in a scandal with the wife of a prime minister, the third Duke of Grafton. He married her when she had been divorced by the Duke by Act of Parliament. Rosenberg's silhouette was painted in 1818, the last year of the Earl's life. On the back of the frame is an oval, blue label surrounded by a garland of leaves. This reads:

ROSENBERG
Profile painter to Their Majesties,
Their Royal Highnesses,
the Prince and Princess of Wales
and
the Duke and Duchess of York
14
Grove, Bath

Evidently, as he grew older, Rosenberg had to face fierce competition in Bath from younger and more competent artists. He advertised 'Lodgings to Let', and a weighing machine 'Where ladies and gentlemen may determine their weight and height for one shilling a season.' In 1804 Mrs Rosenberg announced that she was planning a school for children. Some years later, Royal patronage saved the situation. Rosenberg was appointed a King's Messenger and moved to Windsor. He retired in 1834 and was awarded a pension of £140 a year.

During his long career he had taken profiles of all his Royal patrons, including the infant Princess Victoria.

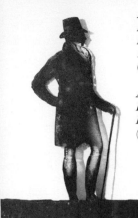

A gentleman, by William Hamlet (Senior) of Bath. Painted on glass. c. 1800. $6\frac{1}{2}$ in. × $8\frac{3}{4}$ in. (Author's collection.)

An officer, by William Hamlet (Senior) of Bath. Painted on glass. (Author's collection.)

HAMLET OF BATH

Collectors are always glad to find silhouettes by William Hamlet who worked in Bath between 1780 and 1815. His finest profiles are full lengths painted on flat glass. Occasionally he used gold foil for details of dress or military uniforms. He also made bust-length profiles on convex glass. Although he was never a resident Profilist to the Royal family like his contemporary, Rosenberg, he could claim Royal patronage. One of his trade labels is headed with the Royal Arms and reads:

<div style="text-align:center">

HAMLET
PROFILE PAINTER
to
HER MAJESTY AND THE ROYAL FAMILY
No. 17, Union Passage,
Bath.
Time of sitting one minute
Prices from 7/6 to 1 guinea.

</div>

Until quite lately an aura of mystery seemed to surround Hamlet. Why was so very little known of his life? It seemed strange, too, how much his work varied in quality. Both Desmond Coke and Mrs E. Nevill Jackson had referred to

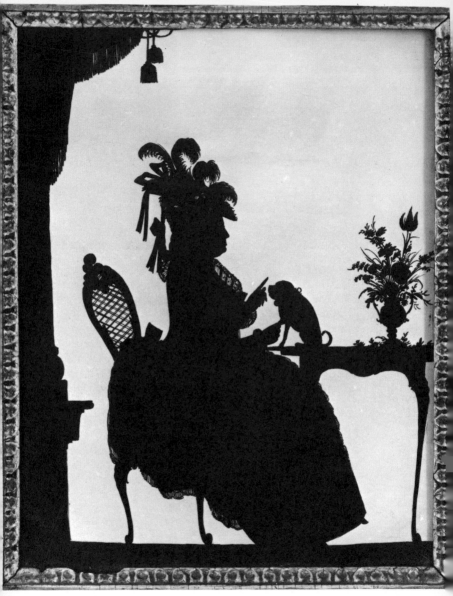

Madame de Genlis, by Walter Jorden. Painted on glass. (Royal Collection at Windsor, by Gracious Permission of Her Majesty Queen Elizabeth II.)

him as 'Hamlet of Bath' (with no initial). Mr John Woodi-
wiss, after some research, partly solved the mystery. There
were in fact two Hamlets, father and son, both named
William. Hamlet senior was the better draughtsman and
became profilist to the Royal family. His studio was first at
17 Union Passage and later at 12 Union Street. Hamlet
junior, the lesser artist, after working with his father, opened
his own studio at 2 Old Bond Street, Bath, and also prac-
tised for a time at Weymouth.

While on the subject of family relationships, one should
mention the brothers Jorden.

THE BROTHERS JORDEN

Two other profilists who painted silhouettes on flat glass
during the closing years of the eighteenth century were the
brothers Richard and Walter Jorden. Nothing is known of
their history but there are some interesting examples of their
work in existence. Silhouettes by Richard are always in
dense, plain black, but Walter sometimes adopted a
semi-transparent style with a greenish background. There is
a fine silhouette by Walter Jorden in the Royal Collection at
Windsor. This silhouette, formerly in the famous Wellesley
collection, shows the full-length figure of a lady with a
pug-dog. It has been described as 'Queen Charlotte'. This
seems unlikely since the lady has an aquiline nose and
determined chin and does not in the least resemble any
portraits of the Queen. I am told that the late librarian, Sir
Owen Morshead, considered it, in fact, a profile of Madame
de Genlis, governess to the French Royal family.

LEA OF PORTSMOUTH

Most writers have praised rare, beautiful profiles made by
Lea who worked in Portsmouth from about 1795 to 1805.
He was a highly-skilled artist who deserves to be ranked
right at the top with Miers and Mrs Beetham.

Lea never used labels but always seems to have pasted
thick blue-grey paper on the backs of his frames. I have seen
at least twenty of his profiles; once studied, his style is easily

33

recognizable. He painted the features and dress of his subjects on convex glasses, with a thin gold border, using a stipple and dot method, resembling an engraving. They were set to throw a double shadow (in a manner previously described). Lea, generally, seems to have painted naval or military men; female portraits, however, do exist. Absolutely nothing is known of his history. Here, surely, is a challenge to the curious collector. I am confident that a little patient research would uncover something about the life of this outstanding artist.

J. SPORNBERG OF BATH

J. Spornberg, a Swede, appears to have flourished in Bath between 1773 and 1810. His work is crude and frankly ugly, but interesting because of the originality of his technique. One writer stated that Spornberg's profiles resembled beer-bottle labels! Spornberg painted profiles in scarlet on the reverse side of convex glass. Black was used for background and outlining features. It is strange, in view of their ugliness, that this profilist's work fetches high prices in London auction rooms; generally more than double the price given for a beautiful silhouette by Miers.

CONVERSATION PIECES

To me there are no more delightful silhouettes than conversation pieces. The man responsible for some of the best, Francis Torond (1743–1812) is today an almost forgotten artist, although his beautiful silhouette groups are well known to those who have studied the art. He was a French refugee of Huguenot descent, who worked in England as a drawing master and professional silhouettist during the last twenty-five years of the eighteenth century.

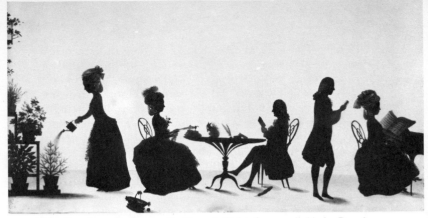

The Parminter family, by F. Torond. Painted on card. (A la Ronde, Exeter.)

Conversation pieces were very popular at that period and many workers in shadow portraiture advertised 'conversations' or 'family pieces'—the older name—on their trade labels.

Torond was undoubtedly the finest of all painters of this type of silhouette. He was a master of decorative effect and each of his compositions is a separate delight.

What exactly do we mean when we describe a painting as a conversation piece? Clearly it must represent portraits of a group of definite personalities in their intimate surroundings. These paintings give us today a valuable insight into the private lives of the leisured classes of English eighteenth century society.

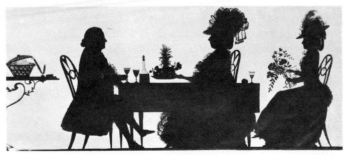

An unknown family, by F. Torond. Painted on card. (Victoria & Albert Museum.)

Francis Torond is known to have worked in Bath before 1784. Afterwards he moved to London and had studios in Berwick Street, Soho and at 18 Wells Street, near Oxford Street. One of his trade labels reads: 'Torond, drawing-master, 18 Wells St. His pupils are properly instructed in Indian ink, chalks or water colours, flowers, landscapes, ornaments or figures; from drawing models or nature. Nobility or gentry attended at their house as usual.'

I have seen bust-length profiles by Torond, but it is for his family groups that he deserves to be remembered. His figures are painted in indian ink on card, and are gracefully grouped; flowers, birds, animals, furniture and household equipment are wrought with the greatest delicacy. A Georgian decanter, silver tea service and porcelain cups, Hepplewhite tables and chairs, all add charm to his well-composed scenes in silhouette.

Many examples of his work still belong to the descendants of their original owners; in some cases they still hang on walls in the very places for which they were designed. An instance is the fine Torond at Renishaw, owned by Sir Osbert Sitwell.

Torond often painted a looped curtain above his groups. Sacheverell Sitwell in *Conversation Pieces* said that, 'this device gives an effect comparable to a beautiful stage scene prolonged by a miracle of time and to be closed, perhaps, by the falling of the curtain.' Of the artist's work, he remarks: 'There could be no better specimens of the conversation piece than Torond's . . . this forgotten person must have been the supreme master of his art of silhouette. His shadow pictures possess the quality of a Beardsley drawing . . . it must have been a limited field in which Torond could express his talents. The law of profile had to be observed, as in an Egyptian or Etruscan painting . . . a glance at silhouettes of lesser masters of the medium, such as Wellings, will serve to establish his perfection.'

William Wellings of Henrietta Street, Covent Garden, to whom Mr Sitwell refers, was a contemporary of Torond. Though not his equal in composition or fineness of detail, he

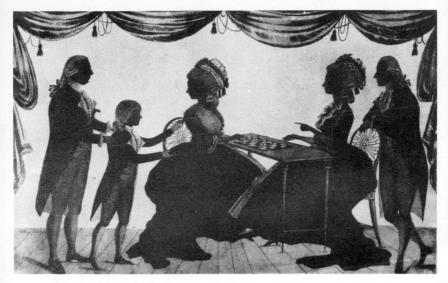

The Austen-Knight family group, by William Wellings, 1783. Painted on card. The Rev. George Austen (left) *presents his son Edward to the Knight family who were to adopt him. Approx. 22 in. × 18 in.* (Major Edward Knight.)

painted conversation pieces and bust-length profiles of great charm. Major Edward Knight, a direct descendant of one of Jane Austen's brothers, has an interesting Austen-Knight family group by this artist.

The Victoria & Albert Museum possesses one group by Torond of an unknown family. The parents are shown drinking a glass of wine and the daughter, called in perhaps from the garden where she was picking flowers, is seated demurely behind her mother. My favourite Torond is of the Parminter family at La Ronde, near Exmouth. This interesting old house was built in 1798 by the Misses Jane and Mary Parminter and it is still in the possession of the same family. Torond's painting hangs above a fireplace in the drawing-room. On the back of it, Miss Mary, the original owner, has written: 'A family piece taken while

living in Grenville St, London, in the year 1793. My cousin, Mrs Jane Parminter, watering a stage of plants; Miss Elizabeth, her sister, netting; Mr Frend reading; Mr John Parminter, her brother, playing a mandoline; and Mrs Frend, her sister, playing on the harpsichord.'

It is possible that conversations by Torond still remain unidentified in some country houses today. Even in the absence of a signature or trade label, they should be quite easy to recognize. Only certain accessories were suitable for Torond's silhouette technique. All the groups I have seen show the same Hepplewhite chairs and identical openwork baskets used again and again.

SOME WORDS OF WARNING

This is the moment, I think, to give a few cautionary words of warning. Genuine conversation pieces are seldom found and, when they do occur, are expensive. This makes them a suitable target for the faker. I have several times been offered paintings on glass, described as 'The Burney Family', framed in old frames and backed with grubby-looking brown paper bearing the appearance of age. These have been copied from an illustration in Mrs E. Nevill Jackson's book *Silhouette* (plate 43).

The original Burney family group, by an unknown artist, would have been approximately 24 × 18 inches in size, but these groups are small, having been traced, no doubt, from the photograph reproduced by Mrs E. Nevill Jackson.

SOLDIERS BY BUNCOMBE

Some of the most desirable silhouettes ever made were the soldiers painted in their gay uniforms by J. Buncombe, an artist who worked at 114 High Street, Newport, Isle of Wight, between 1775 and 1825. They are painted in water-colours on card. The faces are black but the uniforms are in brilliant colour; every detail is correct, down to the smallest badge or button.

Newport was, at that time, a garrison town, which accounts for the fact that most of Buncombe's subjects were

military men. His profiles have sometimes been found pasted in scrap books, so they are not always in old frames. With the exception of conversation pieces, soldiers by Buncombe fetch the highest prices at auction of any silhouettes.

Books which seek to aid the collector by giving current prices always seem to me misleading; often prices have changed before going to press. In 1965 an authority on silhouettes wrote that the average price for a soldier by Buncombe ranged from £12 to £20. In November 1966, six of these silhouettes were sold at Sotheby's. The top price of £100 (a record for this artist) was paid for a fine silhouette of Edward Berkeley Portman, wearing the uniform of the 56th Essex Regiment; two others fetched £50 respectively, and the remaining three, £48, £38 and £35.

Here I should add another warning. Before buying any soldier by Buncombe, always examine it through a magnifying glass. In genuine specimens, the water-colour paint, laid on rather thickly, shows the faint cracks of age. Lately there has been a spate of 'fake' soldiers painted on glass. These have been copied from illustrations in books on silhouettes. The collector should remember that Buncombe always painted on card and *never* on glass. I have even seen these blatant 'fakes' on stands at a provincial Antique Dealers' Fair, exhibited as genuine, no doubt through ignorance of the subject, and not through any wish to defraud.

A gentleman, painted in red on card and bronzed by Edward Foster. (Author's collection.)

3. Silhouettes 1820–1860

By the time of George IV's accession in 1820 the art of silhouette was already on the decline. John Field continued to make well-executed and faithful likenesses until 1841, and a number of lesser men practised during the 'twenties and 'thirties. Some of them, such as Edward Foster of Derby, made very collectable profiles.

Foster was born in 1762 and lived to the great age of 104, having married five times and had sixteen children. His long working career began in the hey-day of silhouettes and overlapped into their years of decline and final extinction. He lived to see the invention of daguerreotypes in 1839 and the introduction of photography in 1851.

Foster became a profilist after being invalided out of the army. He was a great favourite with George III and Queen Charlotte, who not only appointed him Miniature Painter to the Royal family, but gave him apartments at Windsor and frequently invited him to join them in family games of whist. After their death he worked in various parts of the country before establishing himself in his native town of Derby.

In his work Foster was a daring experimentalist. His profiles were generally in light red touched with gold, but he also painted some in blue, brown or black. His earlier silhouettes were framed in handsome papier-mâché frames, bearing the name FOSTER embossed on a gold crown to form hangers. His work can frequently be recognized by a design of tiny triangles of gold dots painted on the clothing of his female portraits. He often signed 'Foster Pinxt' beneath the bust line.

Other artists who did acceptable work in the early years of George IV's reign were H. Gibbs of Ranelagh, who painted on glass backed with wax, and R. Harranden of Cambridge, a painter on card, but from now on, and progressively through the reigns of William IV and Victoria, silhouettes became cheaper and less well executed. They

A lady and a gentleman, by Master Hubard. Cut from paper; details of dress painted in white. c. 1825. 4 in. × 5 in. (Author's collection.)

were no longer finely painted miniatures but were generally full-length figures, often cut from paper, either with scissors or by machine. The delicate touches of gold introduced by Field now became liberal splashes less skilfully applied. Profilists sought to attract customers by advertising strangely named machines. Thus W. Bullock of Liverpool took likenesses with a contraption called a 'Physiotrace', while other men called themselves 'Scissargraphists', or even 'Papyrotomists'. Apparently infant prodigies, of whom there were several, proved popular with the public.

MASTER WILLIAM HUBARD (1807–1862)
The most celebrated infant prodigy was Master William Hubard who became a profilist at the tender age of twelve. In 1832 he advertised in a Norwich newspaper:

> Extraordinary Development of Juvenile Genius.
> Just arrived at Mr Critchley's, cutter,
> Market Place, Norwich.
> MASTER HUBARD, the celebrated little artist who, by a mere glance at the face! and with a pair of common scissors!! not by the help of any Machine, nor from any sketch by Pen, Pencil or Crayon, but from sight alone!!! cuts out the most spirited and striking Likenesses in One Minute—Horses, Dogs, Carriages, in short every object in Nature and Art are the almost instantaneous productions of his TALISMANIC SCISSORS. Likenesses in Bust 1s. Two 1/6. Young children 1/6. Two 2s. Full length 5s. Two 7/6.

A lady, by H. Gibbs. Painted on convex glass with wax background. (Author's collection.)

A Victorian gentleman, painted on card and touched with gold. Artist unknown. $6\frac{1}{2}$ *in.* × $10\frac{1}{4}$ *in.* (Author's collection.)

The child's undoubted gift was exploited by an able showman named Smith. Together they toured Ramsgate, Oxford and Cambridge. Examples show us that little Hubard made astonishingly attractive silhouettes. At this period they bear a small label which states, 'Cut with the Common Scissors, by Master Hubard (aged thirteen years), Without Drawing or Machine.' Later the same year they visited Glasgow where Hubard was presented with an expensive silver palette by the Glasgow Philosophical Society, by whom his exhibition was first named 'Hubard Gallery'. A season in London followed. Then, in 1824 an extensive Irish tour formed a prelude to a visit to America. His arrival in New York, heralded by much publicity, was followed by several extensive tours of the States.

In due course Hubard tired of his long-sustained role of talented infant. At the age of seventeen he cancelled his contract, married and became an American citizen. Subsequently he achieved great success as a painter in oils. In 1862 Hubard joined the Confederate Army and was killed at Richmond, Virginia, by the accidental explosion of a shell.

He had been replaced at the Hubard Gallery by Master Hankes, another, but less talented, British-born infant prodigy.

FREDERICK FRITH OF DOVER

Frederick Frith also began his career as a youthful prodigy. He advertised 'To the Nobility, Gentry and Inhabitants of Tunbridge Wells' that he was in the town and 'Ladies and Gentlemen who have not yet completed their Family sets, are requested to make early application. The extraordinary talented young Master Frith, who has been the astonishment of all lovers of the Arts, will exercise his genius and interesting profession for one week longer in this town, next door to the Ladies' Bazaar.' His prices were modest, ranging from one shilling for busts, to five for full lengths, bronzed and shaded. In his more mature years Frith became a well-known exhibitor of landscapes at the Royal Academy. He worked as a profilist in Scotland during the 1830s, and later in Ireland. In 1840 he opened a studio at Dover. Frith's brushwork was excellent, his silhouettes were cut from paper and then finely painted in gold and white. He added charming backgrounds of patches of flowers or foliage. Although he often signed it, the style and high standard of his work make it easily recognizable. Silhouettes by Frith are desirable acquisitions to any collection.

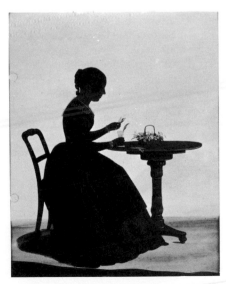

A Victorian lady, painted in red and brown, touched with gold, on card by Beaumont. (Victoria & Albert Museum.)

THE HERVÉ FAMILY OF LONDON

Some mention should be made of the Hervé family who worked in the Strand and at various London addresses between 1820 and 1860. A. Hervé cut and painted full-length figures, using dark grey and black water-colours. Charles Hervé also cut and bronzed silhouettes. A third Hervé, Henry, used similar methods and was the best artist of the family.

W. H. BEAUMONT OF CHELTENHAM

Beaumont worked in the first half of the nineteenth century. He cut and painted full-length silhouettes in dark brown and gold. He often added coloured ribbons and painted chairs, tables and a foreground of patterned carpet.

BRIGHTON PROFILISTS

During the reigns of George IV, William IV and Queen Victoria a number of profilists flourished in Brighton. The small fishing village had expanded into a prosperous town and, as such, became the ideal centre for shadow artists. George IV loved nothing better than visits to his unique Pavilion; in consequence fashionable crowds flocked to the town for the dual benefits of sea air and Royal society.

One of the best Brighton profilists was Frederick Atkinson who had previously worked at Windsor as Profilist to H.R.H. the Prince Regent. His Brighton studio was at No. 4 Old Steine, just opposite his Royal patron's Pavilion. Atkinson cut full-length figures, heavily bronzed, and sometimes groups of figures with well-painted backgrounds.

It is easy to confuse his work with that of his son George, who was also a successful profilist. A close inspection will, however, reveal that silhouettes by the former are cut while those by the latter are painted direct on to card.

During the 1830s Atkinson junior toured a number of watering-places, including Ramsgate, Margate, Teignmouth and Dawlish. After 1839 he settled at the Royal Saloon, Gravesend.

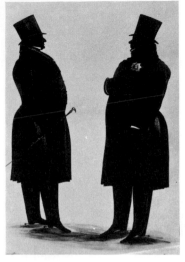

George IV and the Duke of York, by G. Crowhurst. Painted . on card and touched with gold. (National Portrait Gallery.)

In about 1830 Frederick Atkinson was succeeded at 40 Old Steine by George Crowhurst, a competent Victorian profilist who painted full-length figures in brown, black or grey, sometimes touched with gold.

In 1823 the Chain Pier was opened at Brighton. This, the first in the country, was naturally a great tourist attraction.

John Gapp became the first of a long succession of resident pier profilists. He worked in Samson's Royal Saloon, under the third tower of the pier. His profiles were crudely snipped from paper and mounted on backgrounds painted in grey water-colours. His successor on the pier, E. Haines, a slightly better artist, continued in business as a cutter of profiles until after 1850.

Two other Brighton profilists are worthy of note: the first, J. Neville, painted bust- and full-length profiles on card in bluish water-colour touched with Chinese white. His studio was at 4 Poole Lane.

The second, also a good artist, was Adolphe, Profilist to King Louis Philippe, who sometimes painted bust-length profiles of whole families all on one card. He used a very individual shade of greenish-black touched with bronze.

The Hove Museum owns a small collection of silhouettes by Brighton men. Although the Museum is at present closed, permission to view these can be obtained from the Hove Public Library.

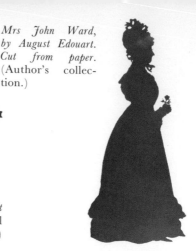

Mrs John Ward, by August Edouart. Cut from paper. (Author's collection.)

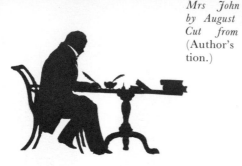

Sir Walter Scott, by August Edouart. Cut from paper. (National Portrait Gallery of Scotland.)

AUGUST EDOUART (1769–1861)

The work of August Edouart stands out above that of all his Victorian contemporaries. He was undoubtedly the finest cutter of profiles from paper ever known. Edouart came to England as a refugee, having previously served as a soldier in Napoleon's army. Like so many *émigrés* he sought desperately for some means of making a living. First, he tried giving lessons in French, then he made portraits from hair. Neither occupation proved profitable but in 1826, by a happy accident, he discovered his gift for cutting likenesses from paper. While dining one night with friends he was shown a crude machine-cut profile. Edouart immediately announced that he could do far better himself with scissors and an old envelope. Challenged to a demonstration, he immediately cut an excellent likeness. This received such praise that he consequently decided to try his luck as a profilist. After first working at Cheltenham, he moved to 14 Old Street, Bath.

Edouart cut full-length figures from two sheets of paper; this habit enabled him to keep a duplicate of each portrait. These he kept in albums, having previously written the subject's name and address, and the date on the back of every profile. He captured a good likeness and both figures and groups are full of life and character. Between 1825 and

46

Edouart's handwriting on the back of the silhouette of Mrs Ward.
(Author's collection.)

1839 he worked in towns all over England, and also visited
Ireland and Scotland. Royalty, authors, university dons
and all kinds of prominent people flocked to his studios.

In 1830 he took the profiles of the exiled Charles X and
his suite at Holyrood. This success went slightly to his head,
and he subsequently showed signs of pompous indignation
that he, silhouettist to the French Royal family, should be
classed as a mere 'caravan man'. Imagine his injured pride,
when walking with 'a lady in high circles', on hearing a
passer-by remark: 'Who can she be, that lady with the
BLACK SHADE man?'

Edouart's silhouettes were always in plain black, collars
and handkerchiefs being indicated by snipping a white gash
at appropriate points. He strongly disapproved of the use of
colour, saying in his book, *A Treatise on Silhouettes*, published
in 1835: 'People with gold hair, coral earrings and blue
necklaces are ridiculous; the representation of a shade can
only be represented by an outline.' He sometimes used
lithographed backgrounds, or in family groups indicated
room furnishings in blackish-brown water-colours. His sil-
houettes were frequently signed 'Aug Edouart fecit', and
the date was added. Like other profilists, he sometimes used
trade labels. On one of the earliest, he stated:

47

Likenesses in Profile

Executed by Mons. Edouart, who begs to observe that his Likenesses are produced by scissors alone and are preferable to any taken by Machines, in as much as by the above method, the expression of the passions and peculiarity of character, are brought into action, in a style that has not hitherto been attempted by any other artist.

This was followed by a list of his charges: 'Full length 5*s*. Ditto children 3/6. Attendance abroad double.'

Edouart took with him on his tours a stock of well-made maplewood frames and his silhouettes are found in these today. Collectors should note, however, that profiles from his duplicate albums will not be signed, and may be in more modern frames, but each will have the name and date in Edouart's handwriting written on the back.

In 1839 Edouart decided to visit America. He took his albums of silhouettes with him and opened his tour with a successful exhibition in New York. From lists of portraits taken, one can see that he visited Boston, Philadelphia, Washington, Saratoga Springs and other towns all over the States. He remained there for ten years and during that time took 3,800 profiles of American citizens. Everyone of importance visited his studios and his silhouettes are today of the greatest historical interest.

Thanks to his industry, there exist today shadow portraits of six presidents and vice-presidents, senators, orators, mili-

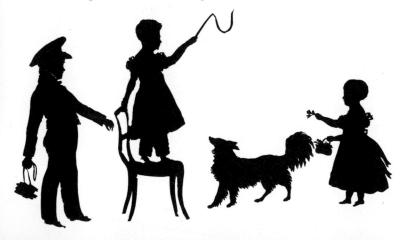

tary and naval men, and many other important personages.

In 1839, the ageing profilist decided to retire to his native land of France. Unfortunately, the boat on which he travelled was shipwrecked off the coast of Guernsey. Edouart was saved but most of his precious albums, containing 200,000 silhouettes, were lost. One folio only was rescued and this he gave, as a mark of gratitude, to the Lukis family, with whom he had stayed after the wreck.

Edouart eventually reached France and settled there for the remainder of his life. He died at Guines in 1861.

In 1911 Mrs E. Nevill Jackson was writing *The History of Silhouettes*. She advertised asking permission to see any examples in private ownership and this led to what must surely be the most exciting discovery ever made by a silhouette collector. A member of the Lukis family of Guernsey offered for her inspection Edouart's album containing 9,000 silhouettes, which had remained unnoticed in their home for sixty years. These profiles, all named and dated, included 3,800 taken in America and 5,200 from England, Scotland and Ireland. Mrs E. Nevill Jackson had the good fortune to purchase the entire album and no one could have put it to better use. She had a complete photographic record made of all the profiles; this, with an alphabetic list of names, is an invaluable asset to portrait galleries in this country and America. The Bibliothèque Nationale in France now owns the originals of the 78 silhouettes cut by Edouart of Charles X and his suite at Holyrood. The National Portrait Gallery of London and the National Portrait Gallery of Scotland each have excellent likenesses of Sir Walter Scott. Mrs E. Nevill Jackson presented a silhouette of President John Tyler to the White House; it had been cut there by Edouart at a special command visit.

In 1921 Mrs E. Nevill Jackson published *Ancestors in Silhouette by August Edouart*. Years of research had gone into this book and she described the lives and occupations of many of the men and women whose shadows she had rescued. A study of names listed led to many descendants acquiring portraits of their ancestors.

The Cockburn children, by August Edouart. Cut from paper. (National Portrait Gallery of Scotland.)

4. America

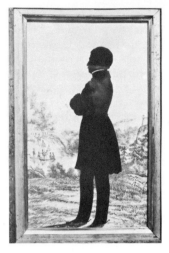

The visits to America of Master Hubard and August Edouart have already been mentioned. A number of other profilists also crossed the ocean to practise their art.

Silhouettes became popular in the New World before the end of the eighteenth century. They are of the greatest value to historians and antiquarians as they represent, in many cases, the only existing likenesses of prominent citizens of that age. America was a rapidly expanding country; new townships were springing up in many places and there were no portrait painters available in some of these centres of population. In any case, the settlers were busy and hard-working people, unable to spare the time or money for expensive likenesses. Under these circumstances the simple art of silhouette met a very real need.

The small populations of American towns made it uneconomic for most profilists to establish permanent studios; for this reason, many found it more profitable to become itinerant workers, travelling from place to place and setting up temporary lodgings. Artists had to travel long distances, sometimes on horseback, carrying the materials of their craft with them. Scissors and paper were easily transportable, but glass or prepared ovals of plaster would have imposed an intolerable burden on the travelling profilist. In general, one therefore finds that the art of silhouette in America remained at its simplest and shadow portraits were mostly painted on card or cut by scissors or machine.

From an artistic point of view, American silhouettes

(Above) *An unknown gentleman, by August Edouart. It is signed 'Augn Edouart. Boston, U.S.A. 1849'. 6 in. \times 9$\frac{1}{2}$ in.* (Author's collection.)

never reached the high standards set by eighteenth-century British profilists, but they provide nevertheless delightful glimpses of early American families.

One of the first visiting profilists must have been Major John André (1751–80), who was born in Geneva, but after joining the British Army was drafted with his regiment to America. He was a gifted amateur cutter of silhouettes. Two examples of his work, profiles of Benjamin Franklin and George Washington, were excellent likenesses. André came to an unfortunate end. He was embroiled in the treacheries of Benedict Arnold and eventually was executed after his capture by American forces.

Samuel Metford was another visitor. He came of Quaker stock and was born at Glastonbury in 1810. Metford made extensive tours of the States. He appears to have prospered and became an American citizen. In old age he returned to England and died there in 1896. Metford painted full-length figures and family groups embellished in white and gold, often with painted backgrounds.

Early American-born professionals include Samuel Folwell (1765–1813), who painted miniatures as well as profiles; Moses Chapman (1783–1821), an itinerant worker in Massachusetts who cut by scissors and machine; Charles Peale Polk (1767–1822) of Maryland, a painter of black profiles on glass with gold backgrounds, and Samuel Brocks, a Boston profilist and miniaturist.

Charles Wilson Peale was a well-known cutter of silhouettes who combined the *métier* of profilist with that of dentist, silversmith, saddler and taxidermist. William Henry Brown (1808–83) was one of the best American profilists. He cut full-length figures in a style which resembled that of Edouart.

William Doyle of Massachusetts (1756–1828) was the son of a British officer stationed at Boston. On his trade label he claimed 'Forcible animation' and mentioned that profiles could be supplied 'On Composition, in the manner of the celebrated Miers of London: Prices of profiles, 1, 2 and 5 dollars.'

Altogether the names of more than forty American silhouettists have been recorded. To these can be added a further twenty visitors to America who practised the art. A full description of them and their work can be found in *Shades of our Ancestors*, an excellent book written in 1928 by A. van Leer Carrick (published by Little, Brown & Co., Boston).

A White Friar, Gabriel von Ritter. Austrian verre églomisé silhouette on glass. Black with gold background. Signed 'Stanzell fecit'. 2¾ in. × 2¾ in. (Author's collection.)

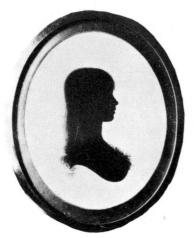

Master James and Miss Elizabeth Steuart, 1785, by S. Houghton. Set in a gold locket. (Victoria & Albert Museum.)

5. Odds and Ends

One sometimes sees, in auction rooms or antique shops, silhouettes on glass with gold backgrounds. This method, known as églomisé, was popular on the Continent during the late eighteenth and early nineteenth centuries.

The decoration of glass with gold or silver foil was known in early Christian days, but it is a curious fact that the word *églomisé*, used to describe this process, was coined in the eighteenth century from the name of Jean Baptiste Glomy, a French artist, writer and antique dealer, who practised the art of under-glass painting. Technically these were the most difficult of all silhouettes to make. The artists who made them were superb craftsmen who exercised infinite patience and scrupulous attention to detail. Both qualities are national characteristics in Germany, so it is hardly surprising to find that most silhouettes in *verre églomisé* were made by German or Austrian artists. German taste in the decorative arts, whether it be in glass, porcelain or furniture, is more ornate than our own, so no doubt the richness of the gold backgrounds appealed to the German public. These silhouettes were made in all types and sizes: elaborate full-length groups of figures, hunting scenes, memorial pictures and even in minute sizes for jewellery or snuff boxes.

In 1780 a German profilist in Münster, P. H. Perrenon, published a treatise on silhouette-making, in which he described the *verre églomisé* method. Briefly, the underside of the glass was covered with black pigment. On this the profile was outlined by needle point and the surrounding surface was entirely scraped away. Details and decorative borders were also etched by needle. Finally, gold or silver foil was placed over the entire surface to provide a background which was held in place by a thin coating of wax. Sometimes the process was reversed and a gold profile would be on a black ground.

53

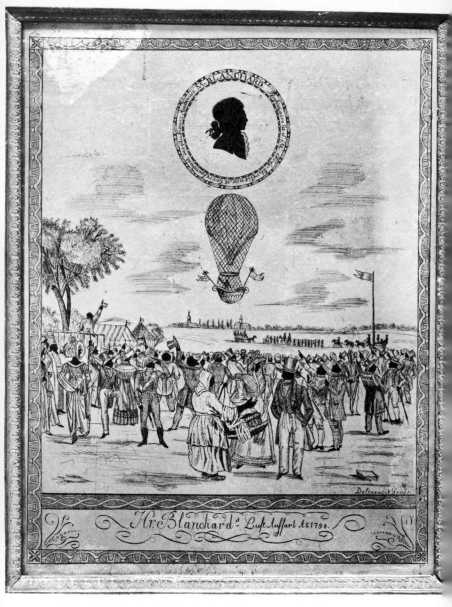

Eglomisé silhouette of Blanchard's balloon ascent, by Leopold Gross of Vienna. (Victoria & Albert Museum.)

Small profiles in *églomisé*, with their gleaming back-grounds, are often very decorative and add lustre to any collection.

Collectors interested in porcelain and silhouettes can combine both interests. I have made brief reference to silhouettes painted on china by the Worcester factory. Profiles as decorations were also used at Bristol.

Portrait silhouettes became popular with a number of porcelain factories on the Continent from the second half of the eighteenth century to the first quarter of the nineteenth. Whole services decorated in this manner are, of course, museum pieces, but one occasionally comes across cups, saucers, plates or vases. Silhouettes were used for gift or commemorative pieces and were the forerunners of the crude profiles on pottery to mark the coronations and jubilees of all British monarchs since Victoria. In Germany, Frederick of Prussia was a favourite subject. His profiles and many others appear on pieces made at the Dresden, Nymphenberg, Fulda, Höchst and Gotha factories. Nyon, in Switzerland, also used shadow portraits as decoration. In France, Mirabeau's silhouette was painted on a service of Sèvres, and that of Benjamin Franklin on a cup and saucer; perhaps made between 1780 and 1785 when he was American Ambassador to Paris.

It is, even at today's prices, possible with patience to gather a selection of silhouettes painted on porcelain. In time, such pieces will increase further in value.

No account of silhouettes would be complete without a brief description of the beautiful miniature profiles painted on chips of ivory or glass, set in rich settings of gold or pinch-beck, and sometimes encrusted with precious stones or pearls. Silhouette jewellery includes rings, brooches, brace-lets, lockets, tie-pins, card-cases and snuff boxes. The collec-tion of such rare pieces is likely to prove an expensive

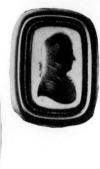

(Above right) *A man, painted by John Miers, set in a brooch.* (Author's collection.) (Right) *A lady, painted in ivory by John Miers, and set in a brooch.* (Author's collection.) (Left) *A lady, by John Miers, set in a ring.* (Author's collection.)

hobby, suitable for the attention of the most well-endowed and ardent devotees of silhouette.

It was the fashion in the late eighteenth and early nineteenth centuries to distribute mourning rings among close friends and relations after funerals. Minute 'shades' of the departed were rightly thought suitable for such gifts.

Many profilists advertised their willingness to undertake profiles for jewellery. John Miers and his school were supreme masters at painting these tiny gems.

Likenesses on brooches, lockets and tie-pins were exchanged between lovers, for, as suggested on his label by C. H. Sandhegan, a Dublin profilist: *'Dans L'absence du réel L'ombre me content.'* An extra touch of sentiment was provided when strands of the subject's hair were plaited and set at the back of the frame.

The most likely place to find these beautiful little pieces is not in antique shops but on the trays of old jewellery displayed in the windows of jewellers.

BOOKS AND PRINTS

Silhouettes were often used to illustrate books in the eighteenth and nineteenth centuries. They made delightful frontispieces to innumerable volumes of biography: the lives of naval captains, the sermons of clergy, history by Gibbons, etc. An edition of *The Poems of Robert Burns*, published in

The Duke of Wellington. Silhouette print by I. Bruce of Brighton.

1834 by James Cochrane and Company, 11 Waterloo Place, Edinburgh, contains a silhouette of the poet taken from the original by John Miers.

Collectors in the past have argued as to whether Miers drew his profiles free-hand or, like many of his contemporaries, first drew a life-sized shadow and reduced this by means of a pantograph to the required size. Mr John Woodiwiss solved this question; in his book, *British Silhouettes*, he quoted some interesting notes appended to the 1834 edition of Burns's poems, in which the writer said: 'A skilful profilist, Mr Field of the Strand, London, favoured the Proprietor with a copy of the profile of Burns, carefully reduced from the life-size outline taken at Edinburgh by

Miers', and adds: 'The accompanying engraving was executed with faithfulness and spirit and must be looked upon, with the exception of Nasmyth's picture, as the only authentic memorial in existence of the great poet. Burns sat for his profile in 1787; a letter of the poet, still extant, alludes to this: there is, moreover, the memorandum book of the artist in which the entry both of the time and price is made, and more than all, there exists, in good preservation, the life-sized outline traced on oiled paper from which the miniature profile was taken, with the Bard's name, as was the custom of Miers, written on it.'

Silhouette prints, or books containing silhouettes, make an interesting addition to a collection. An English edition of Lavater's *Essays on Physiognomy* is generously illustrated with engravings, including a fine portrait of George Washington, engraved by T. Holloway from a painting by Stuart. There are also quantities of silhouettes, among them likenesses of Frederick of Prussia, George III and Goethe. Quite apart from illustrations, it holds a charming appreciation of the art of silhouette. At the time of publication it was a best-

William IV. Silhouette print by I. Bruce of Brighton.

Midshipman Edward Baker. Painted on plaster, late eighteenth century, by John Miers. 2½ in. × 3 in. (Ex Nevill Jackson collection; now Author's collection.)

seller, so even today the collector will find it fairly easy to obtain at no great cost.

Edouart's *A Treatise on Silhouette Likenesses*, published by Longmans in 1834, is also full of interesting silhouettes but it is scarce and hard to find.

Easier to discover, and sometimes to be had for a few shillings, are some attractive silhouette prints made by I. Bruce of Farringdon Street, London and Somerset Place, Brighton. His subjects were all prominent men of that period: William IV, with legs crossed, sits at a table drinking port; beneath is a caption: PEACE AND AFFECTION TO ALL. The Duke of Wellington, with his feet up on a chair and the words 'A Commander in Retirement'; Lord John Russell, Lord Brougham and Daniel O'Connor, also appear in this very collectable series.

WHAT TO SEEK AND WHERE

I hope that by now those who have read this book will feel that they have some grasp of the subject and an insight into the joys of silhouette collecting. Some may wish to begin collections of their own. What should they seek? Their highest aim will, of course, be eighteenth-century silhouettes

59

by Miers, Mrs Beetham or other masters of the art, in authentic frames and, if possible, labelled.

Secondly, the work of late Georgian or Victorian artists such as Foster, Frith, Beaumont, Master Hubard or Edouart.

I would suggest that a delightful collection might still be made of children in silhouette. Pastels and paints show the delicate colouring of children better, but silhouettes, particularly those rapid impressions cut by Victorian artists, portray a familiar attitude or characteristic outline. They show us children with their favourite pets or toys and often afford a charming insight into children's fashions of that period. There are teen-age beauties, with soft ringlets pencilled in gold by Frith of Dover, schoolboys in mortar boards painted in reddish-brown by Foster of Derby, lively groups by Edouart or sturdy infants in petticoats by Master Hubard.

A favourite silhouette in my own collection, by an unknown artist, shows a very young boy (yes, it *is* a boy) wearing an off-the-shoulder dress with puff sleeves. On the back is written: 'Willie, Ramsgate 1834, a gift from Mrs Humphrey.'

Shadow portraits cut with scissors by Victorian artists gave a rapid impression rather than a detailed miniature. Children rarely stand still for more than a moment, but that moment was captured by these almost forgotten men; with their trained eyes and dexterous scissors, they have left us these somehow rather poignant shadows of the children of a vanished age.

Next, where can silhouettes be found? There is a tremendous element of luck in collecting and I have come across good silhouettes in junk shops, country-house sales and on the stalls of street markets. I have always found London a good hunting ground. Not, naturally, the expensive premises of West-End dealers, but in the countless small shops to be found down by-roads and side streets. Some dealers have scarcely heard of silhouettes, but the collector will soon discover for himself others in country towns and

Victorian infant. Artist unknown. (Author's collection.)

Victorian girl. Artist unknown. (Author's collection.)

A Victorian boy, Master Willie Humphrey. Cut by an unknown artist.
$3\frac{1}{2}$ *in.* × *5 in.* (Author's collection.)

London who specialize in them and usually have some 'put by' for regular customers. The keen collector will haunt such shops and, in due course, his persistence will be rewarded.

Glass and wine label collectors have their own Collectors' Circles. Nothing like this exists for the silhouette collector at present.* There is, however, a bond among those who share a mutual interest and I have always enjoyed meeting other collectors and seeing their collections.

*Mr Donald Gildea (himself a collector) intends to form a silhouette collectors' circle. Those who are interested should write to him at 15 Shelley Road, Bognor Regis.